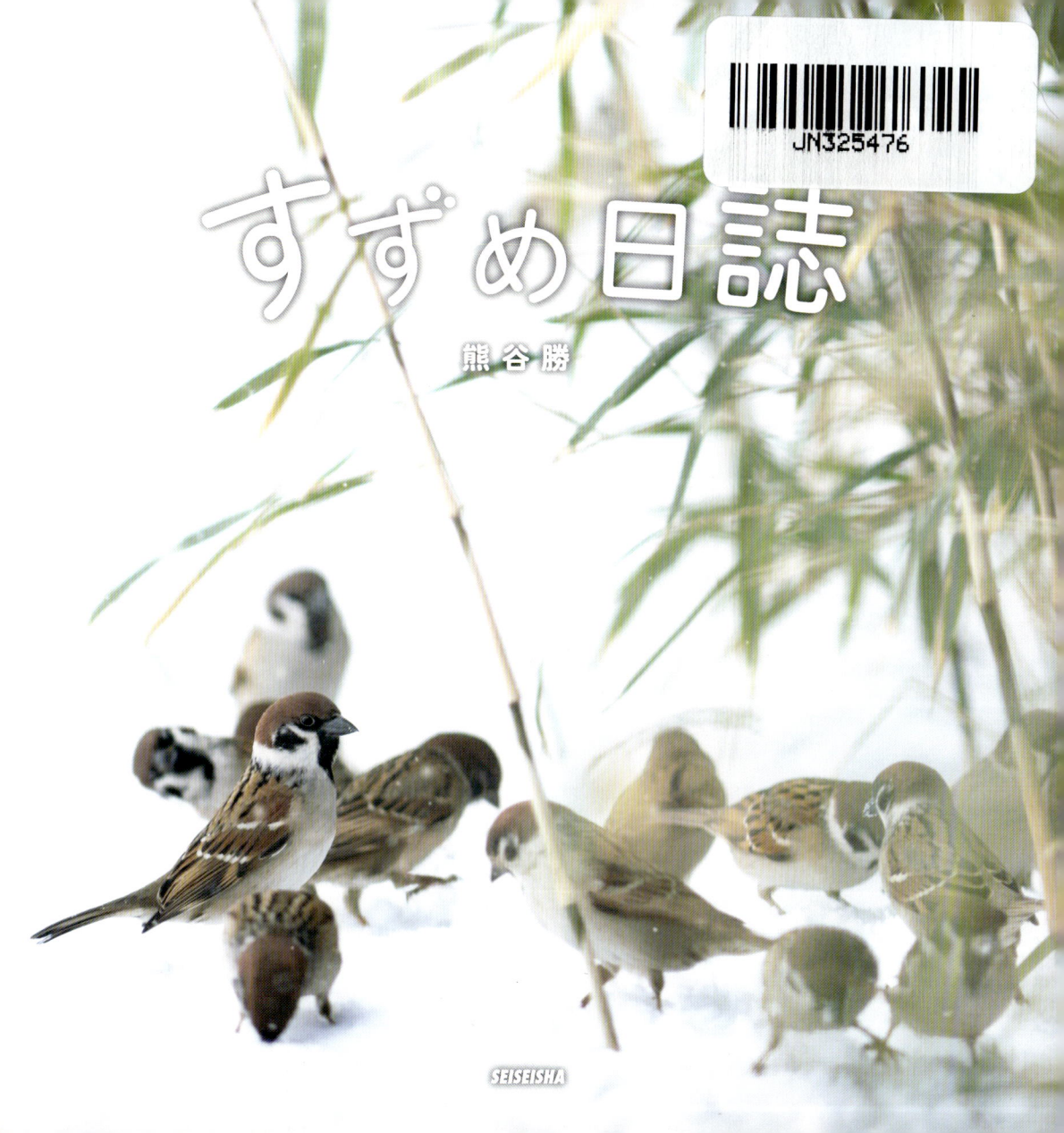
すずめ日誌

熊谷 勝

SEISEISHA

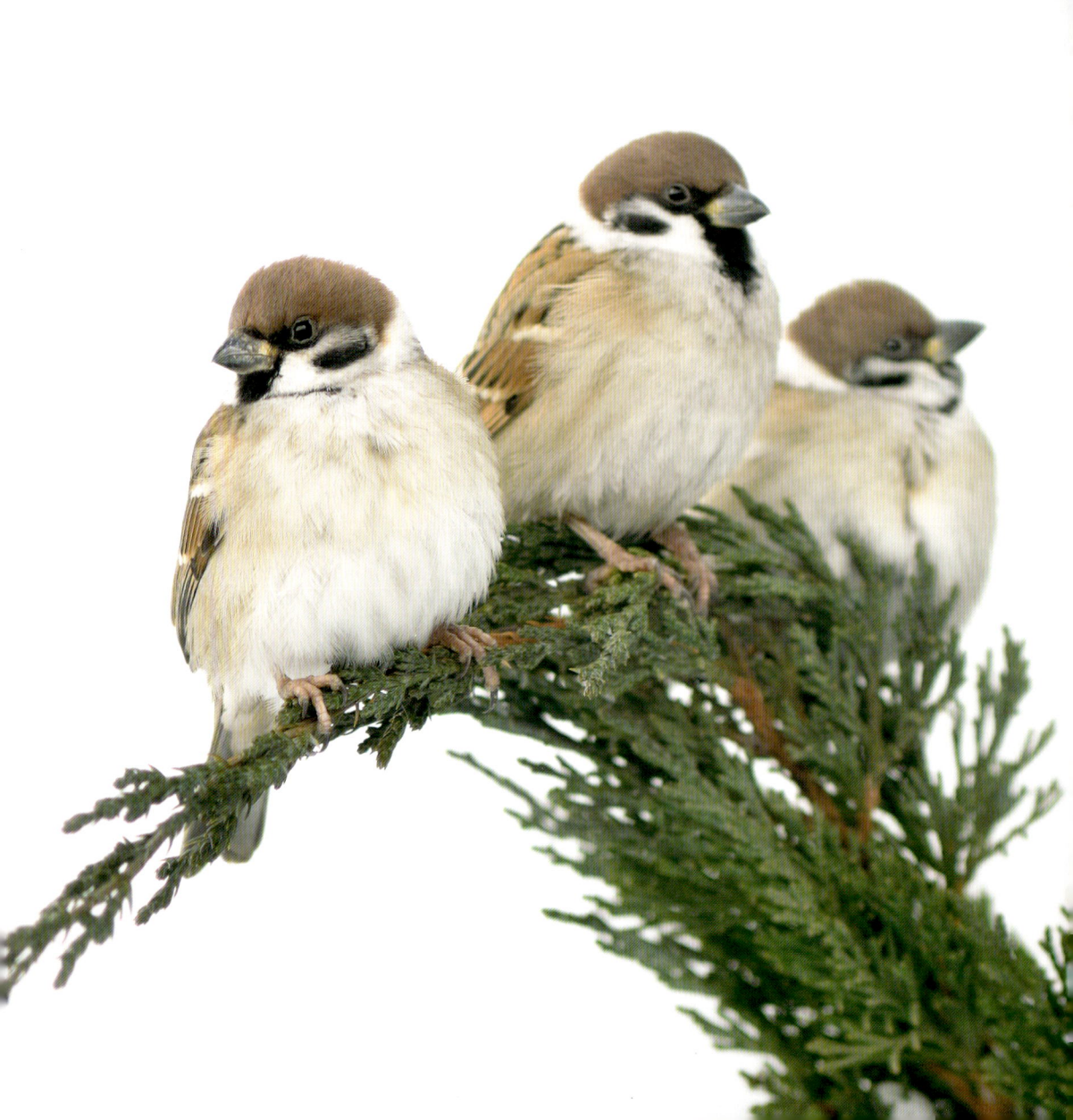

初冬のある朝、
庭木の枝に仲良く三羽のスズメがとまっていた。

普段見馴れたはずの鳥だが、
よく見れば頭でっかちで何とも可愛らしい。

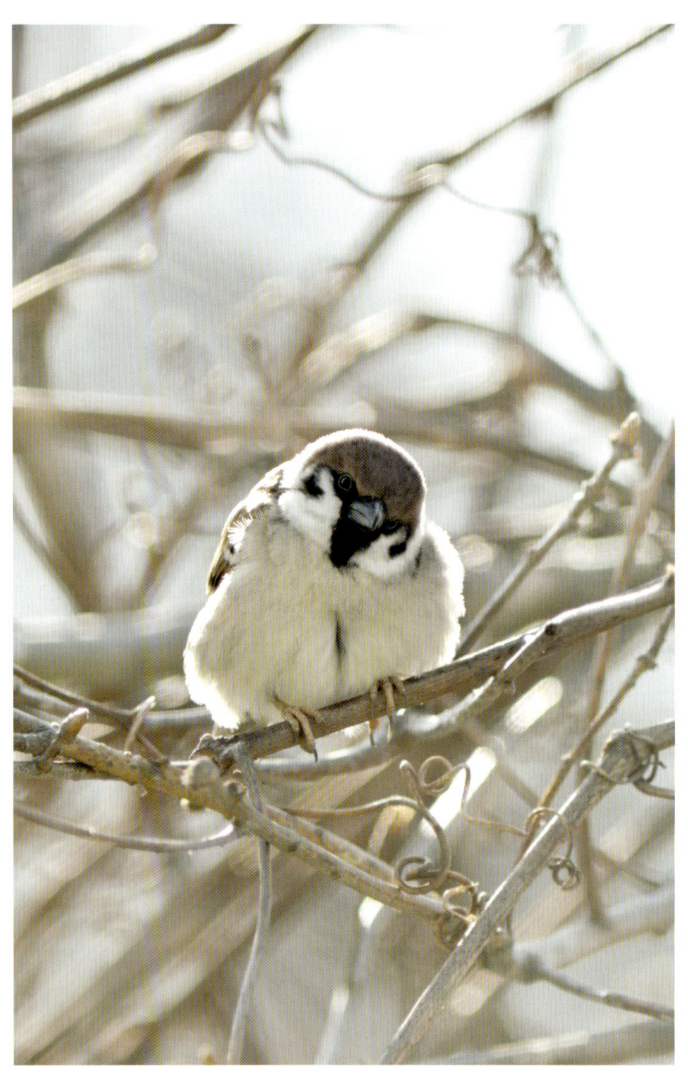

「ふくらすずめ」
という言葉がある。

その名の通り、冬のスズメは
ふっくらしていて丸っこい。

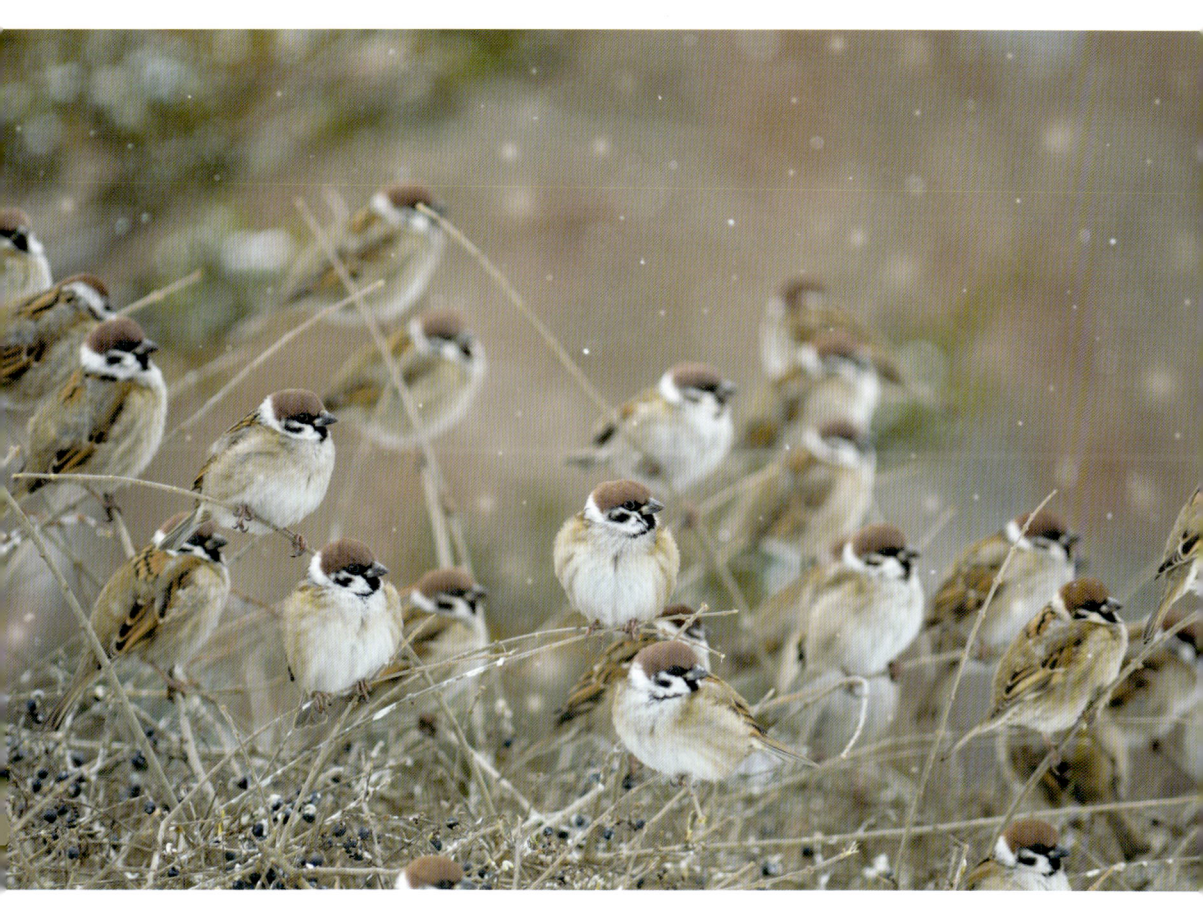

庭の生垣にとまる数十羽のスズメたちがただじっと、降りしきる雪を眺めていた。

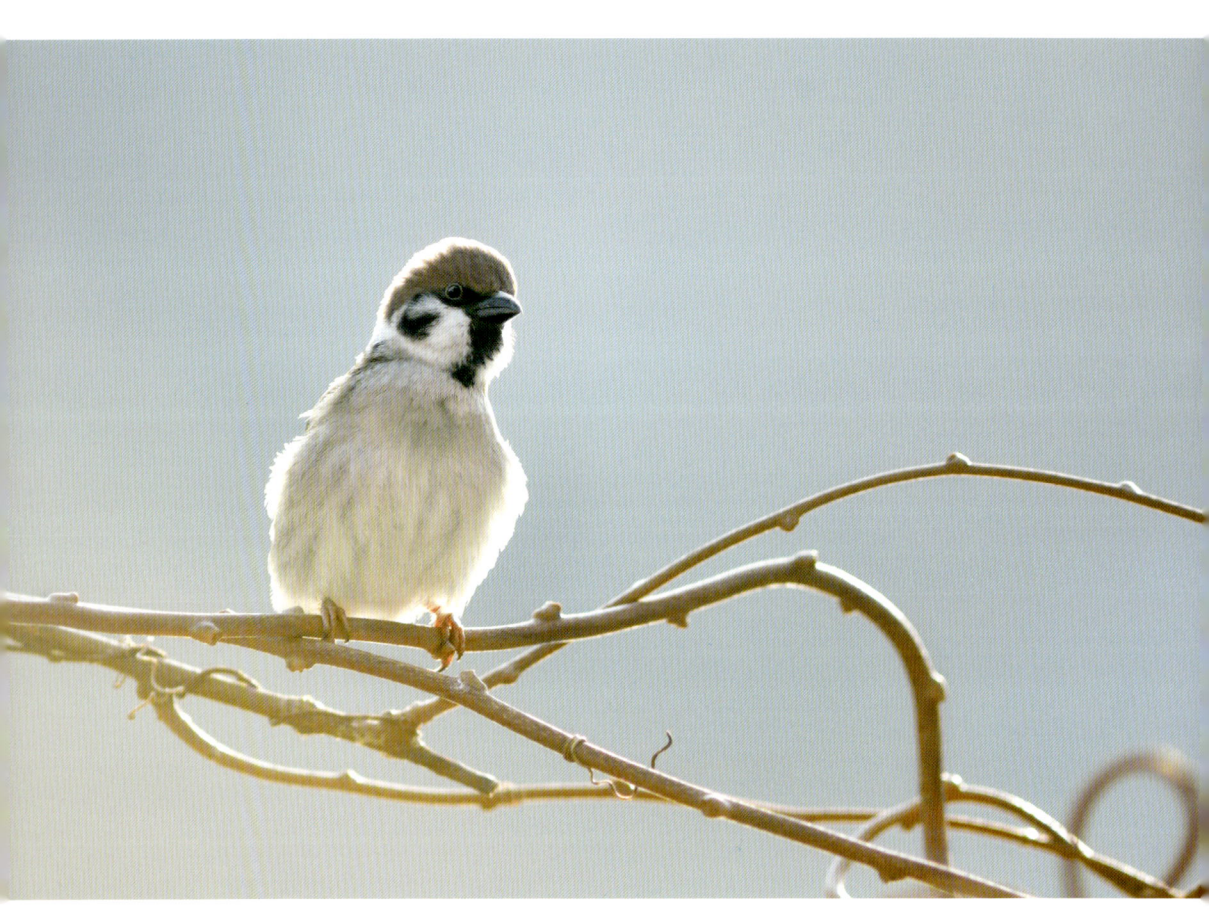

冬の朝、暖かな日差しがスズメの体の羽毛を輝かせる。

今朝もお気に入りの枝で
身支度が始まった。

スズメたちの一日が始まる。

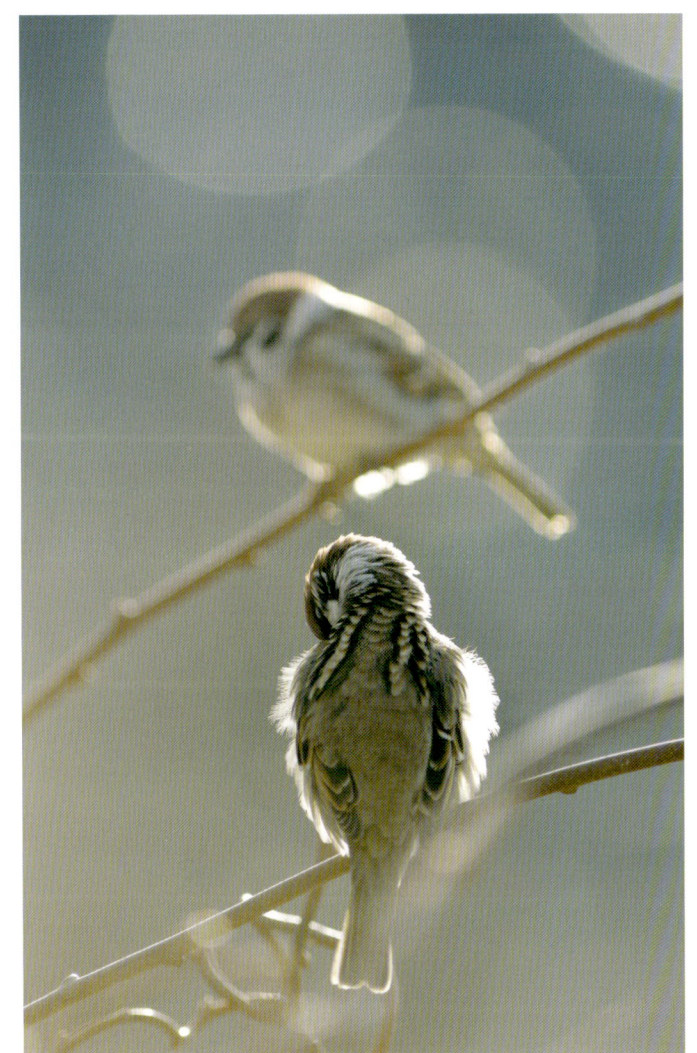

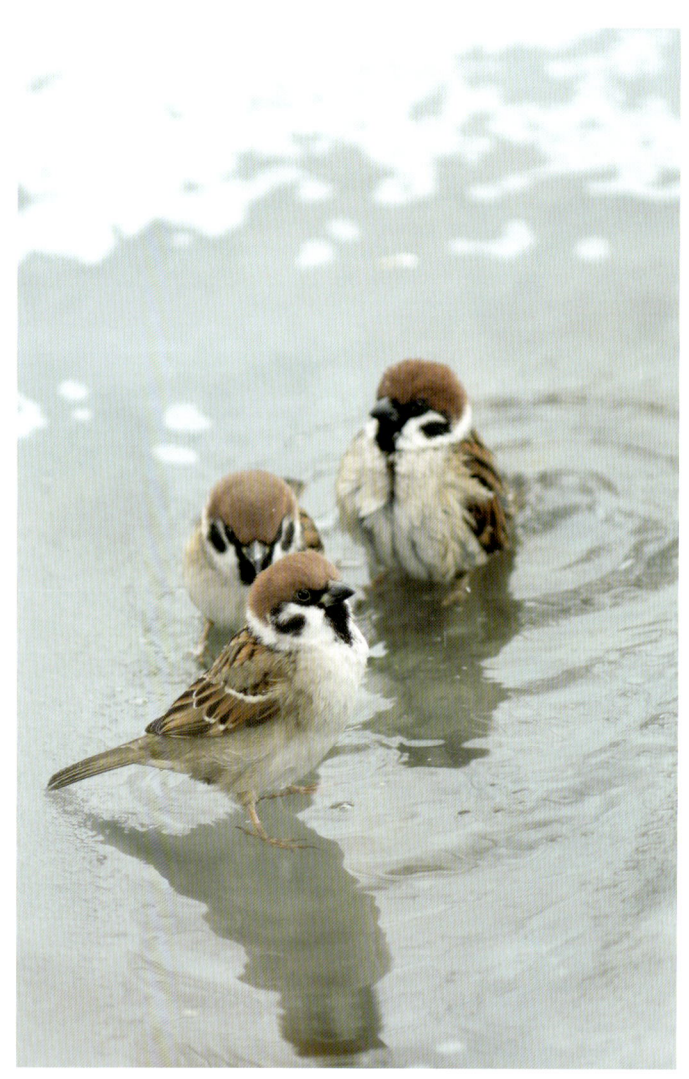

日中、池の氷が少し溶けると、
大好きな水浴びタイムだ。
冷たくはないのだろうか。

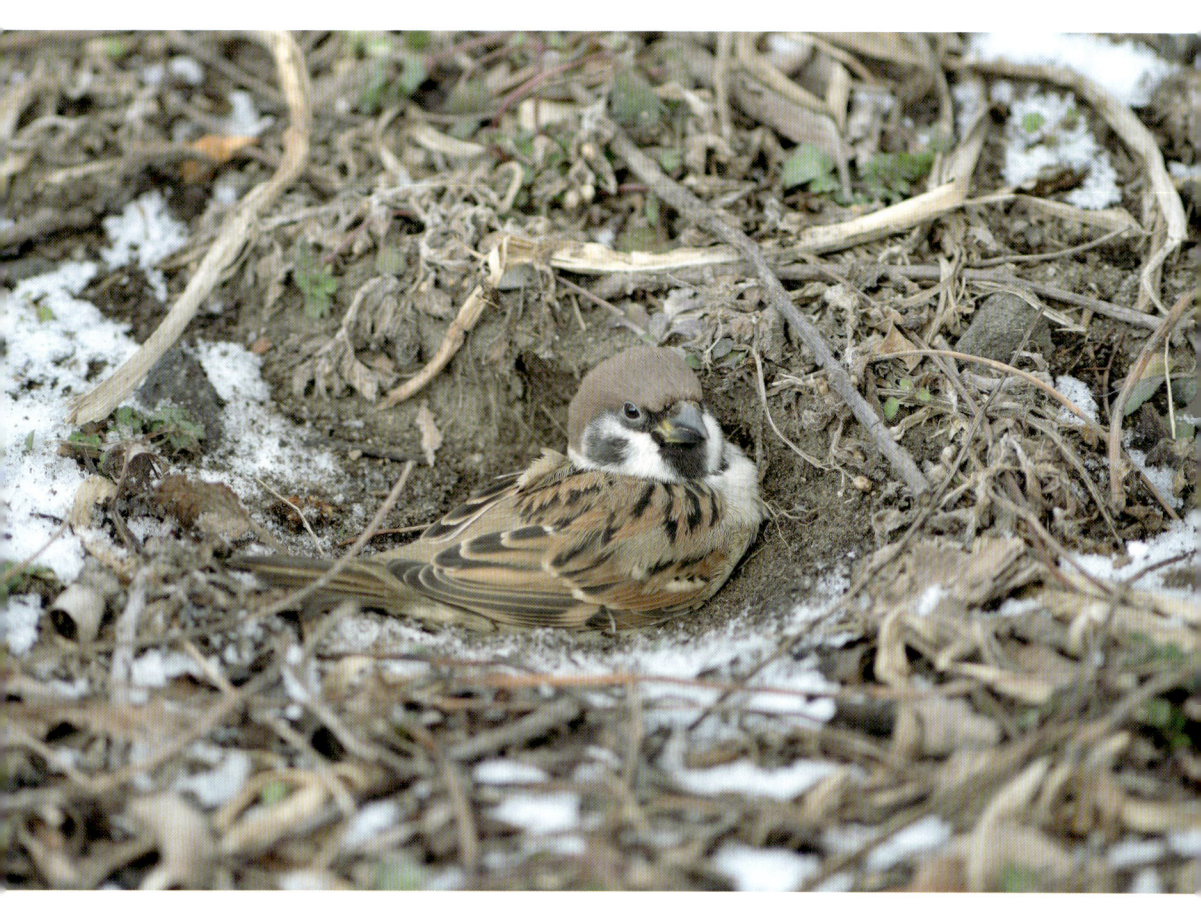

体に付いたダニなどをとるため、スズメたちは砂浴びも欠かさない。

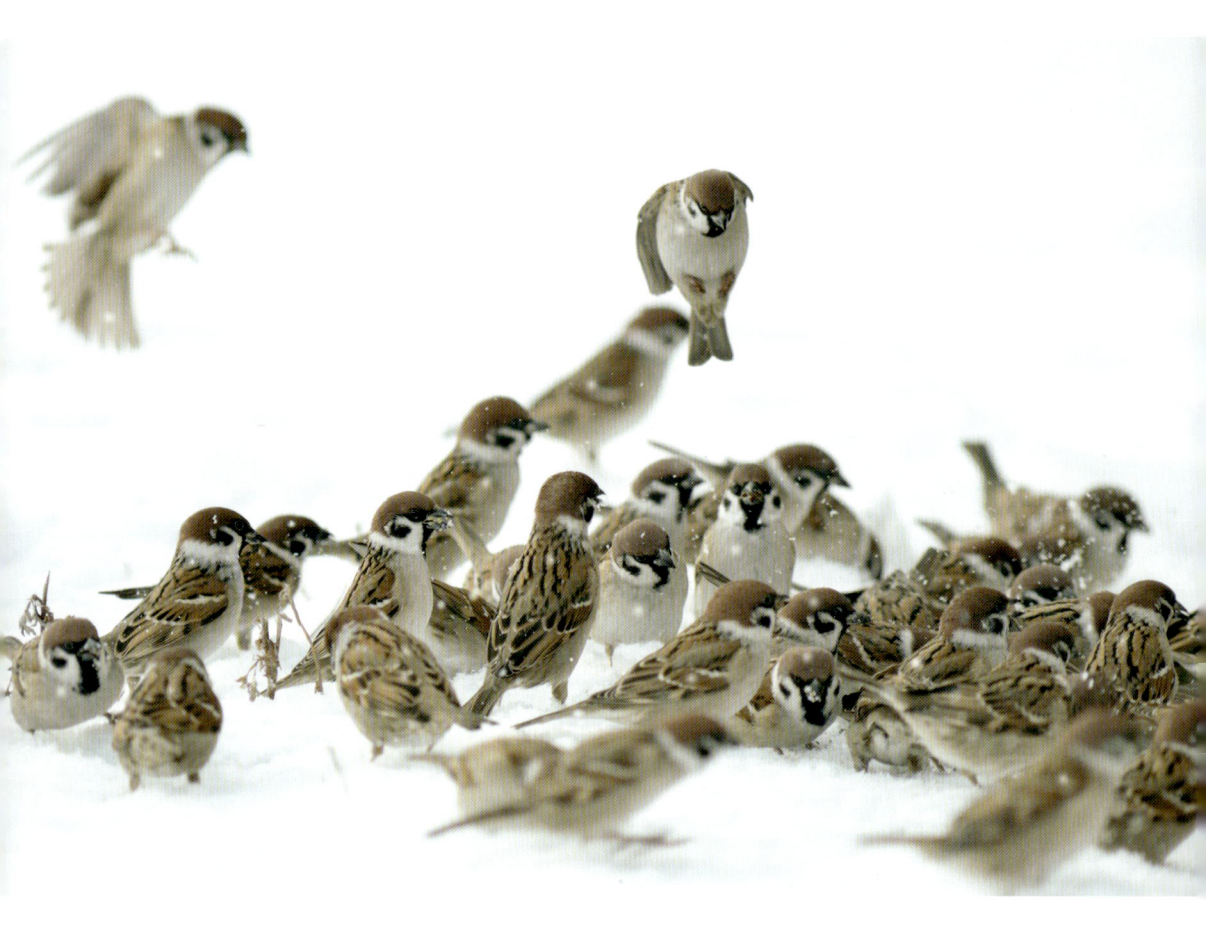

今朝もスズメの群れが、田んぼの落ち穂を食べに次々と飛んできた。

餌を食べ終えたスズメたちが
一列に並んでひと休み。

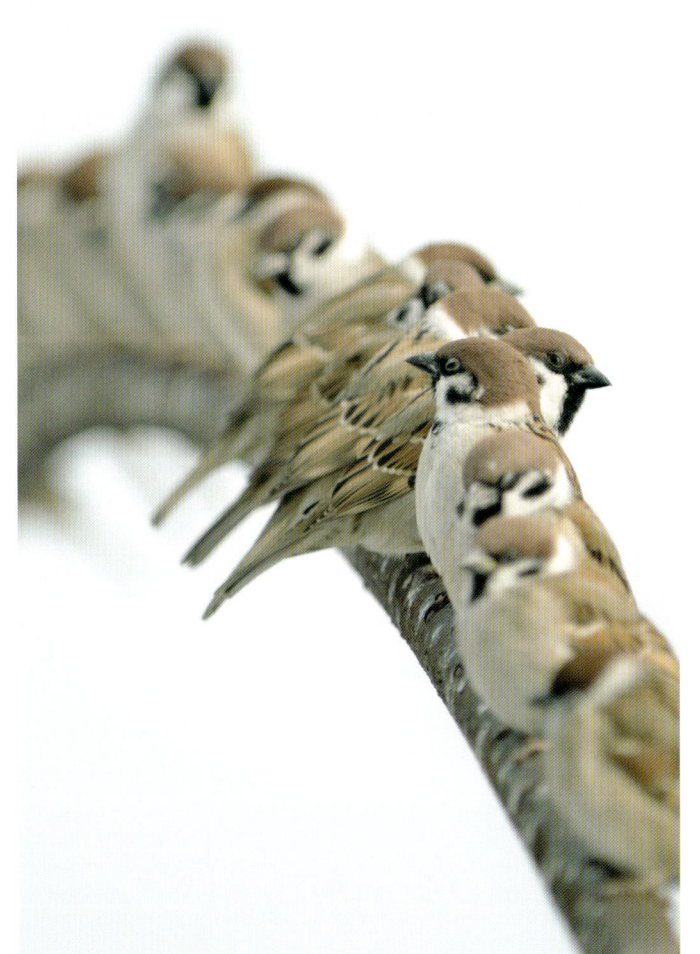

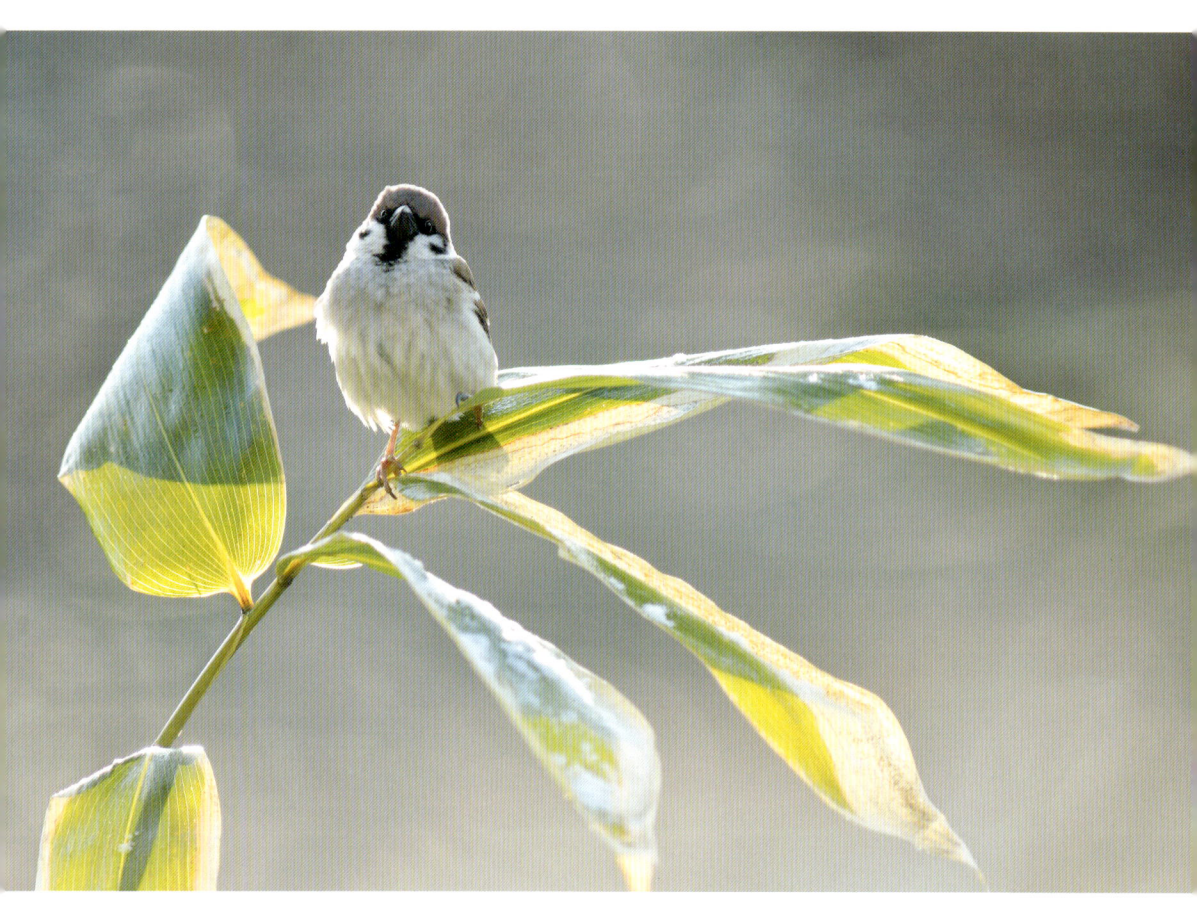

笹にうっすらと雪が積もった朝、
レンズを向けた私をしばらく不思議そうな顔で眺めていた。

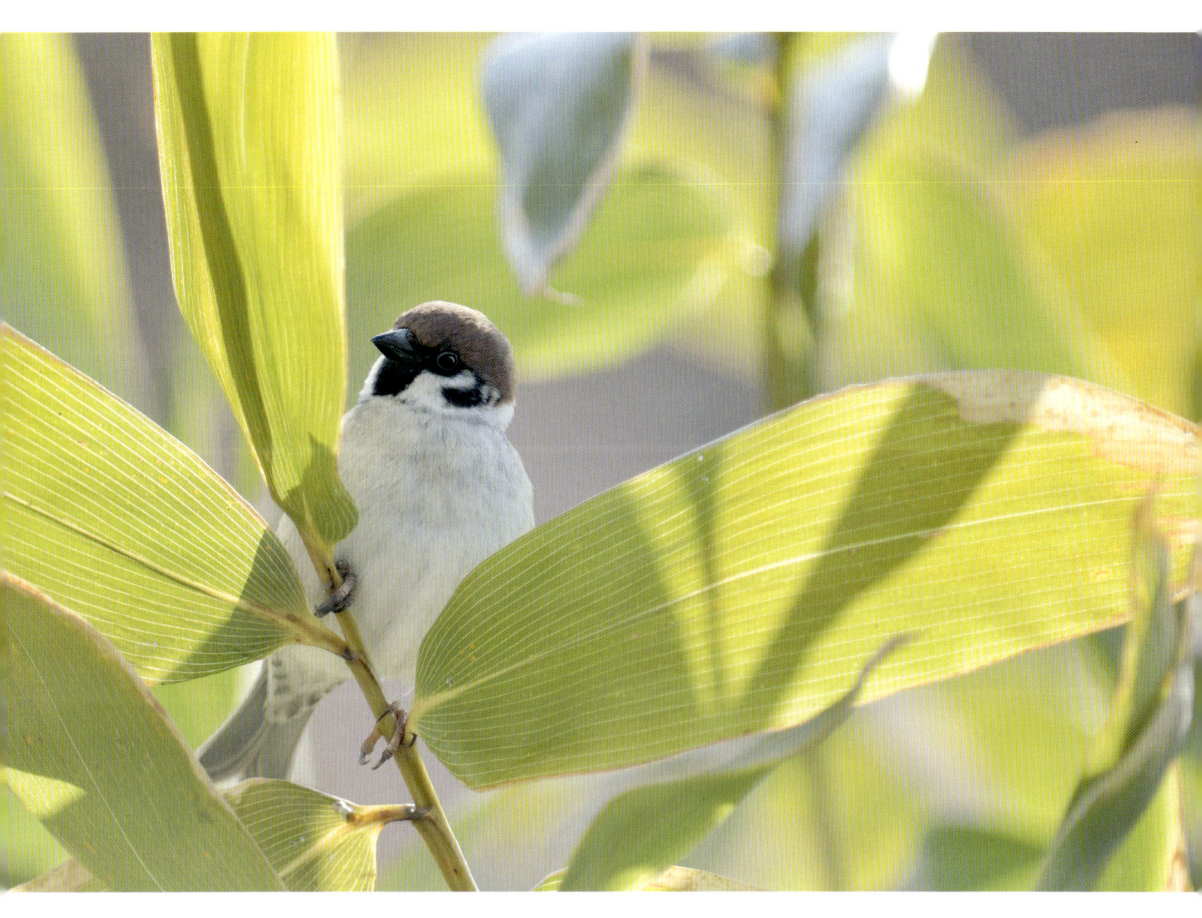

私に気付いたのか、笹の葉の陰からひょっこり可愛い顔を出してくれた。

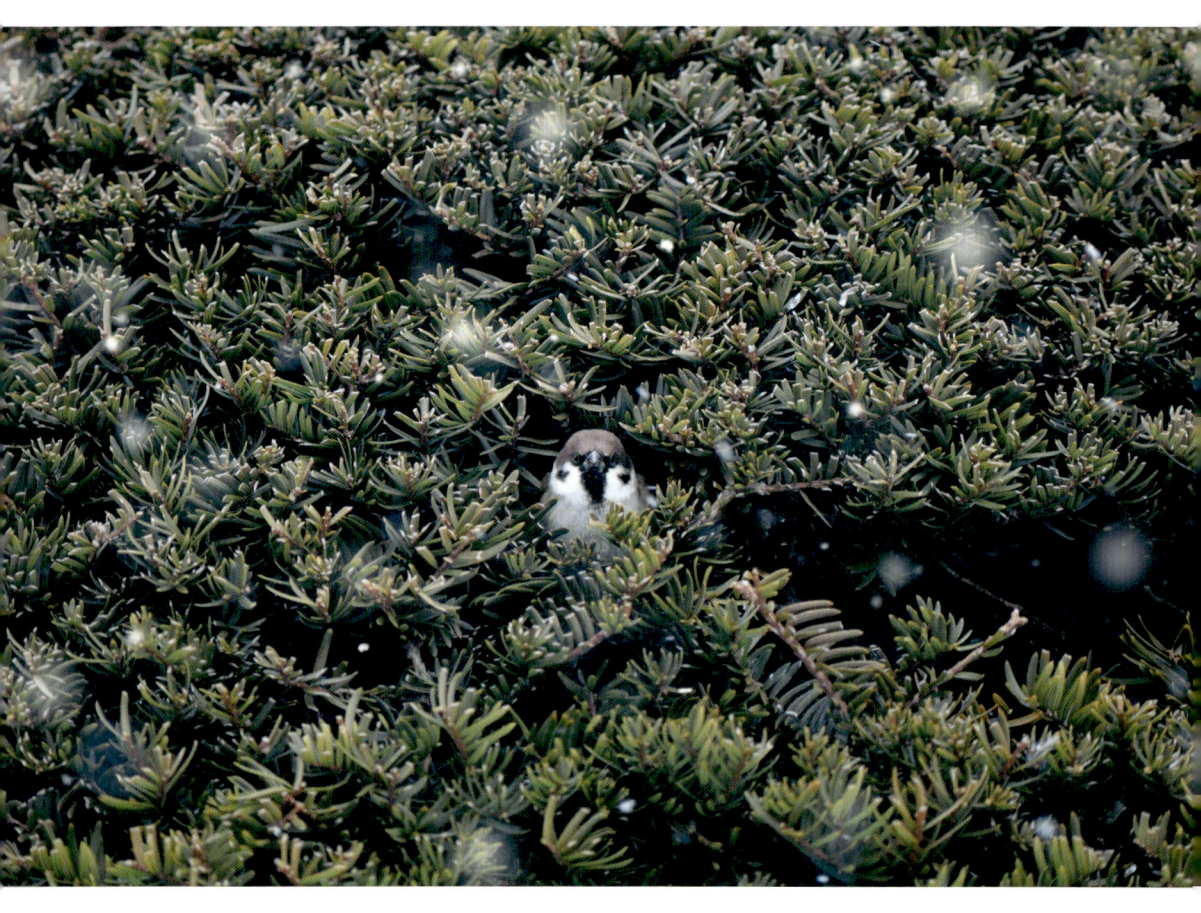

スズメたちは危険を感じると、庭の針葉樹の茂みの中へと入りこむ。
一羽が辺りをうかがう。

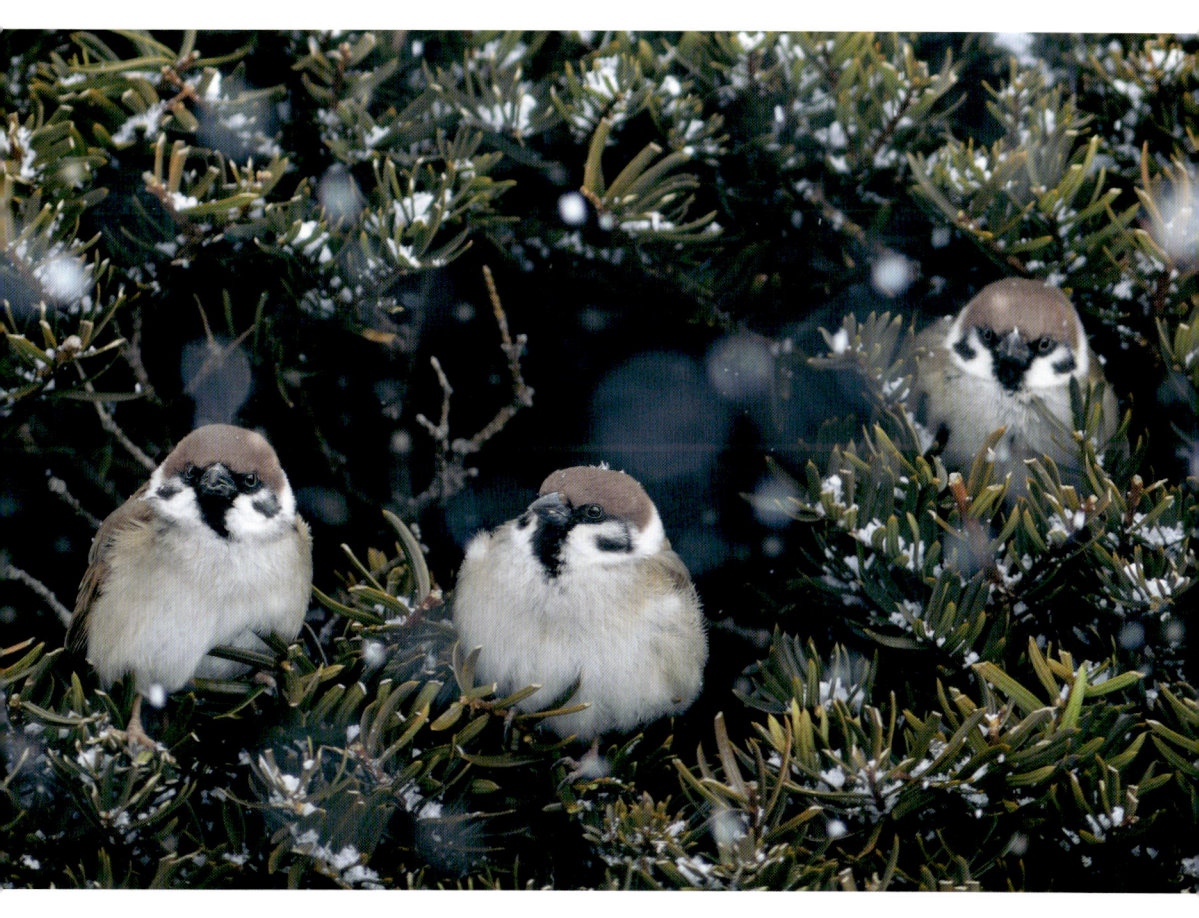

安心すると、茂みの中から次々に顔を出し始める。

大分雪が降ってきた。

スズメたちは雪を避けるため、
次々にねぐらの笹藪へとやって来る。

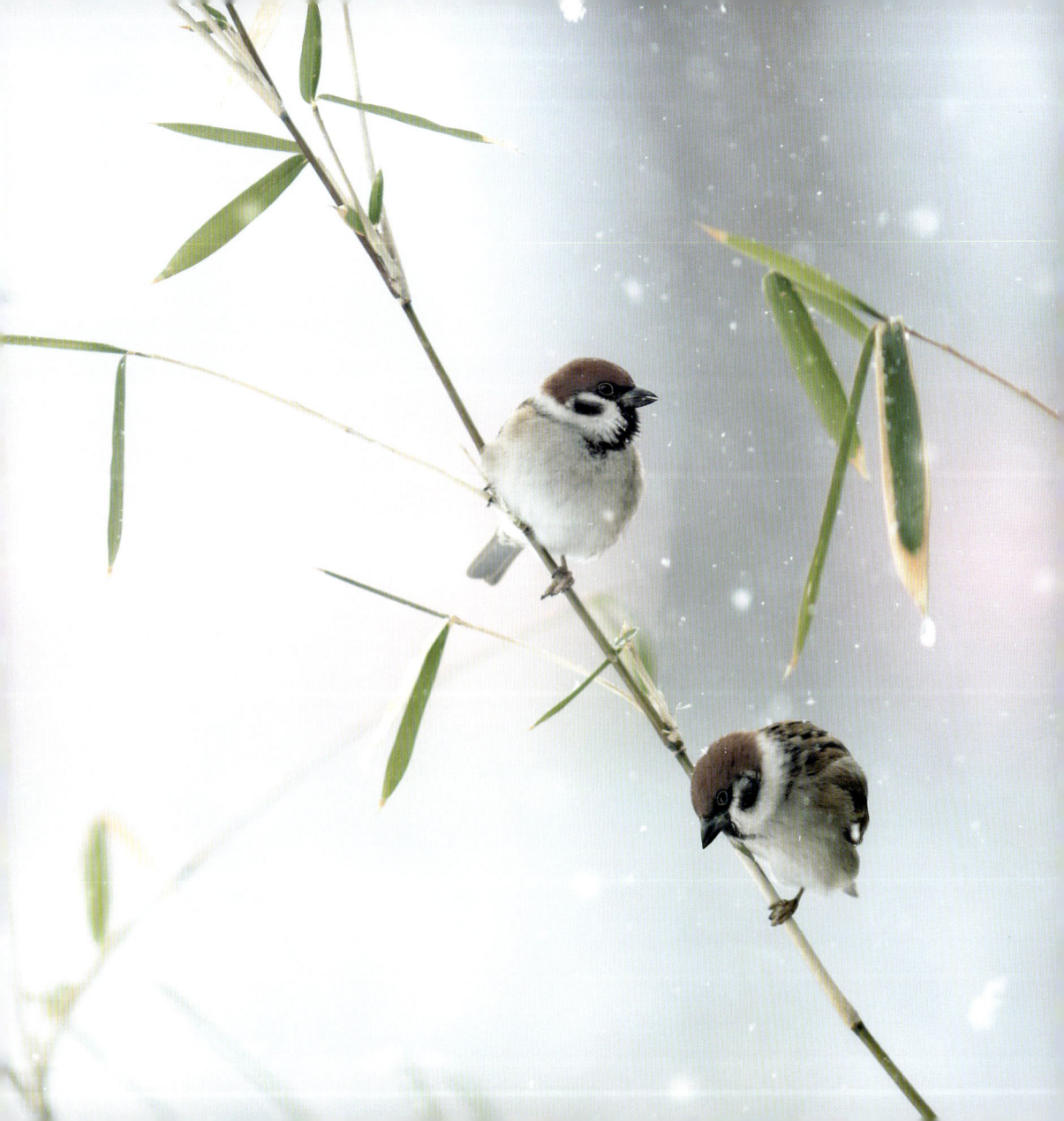

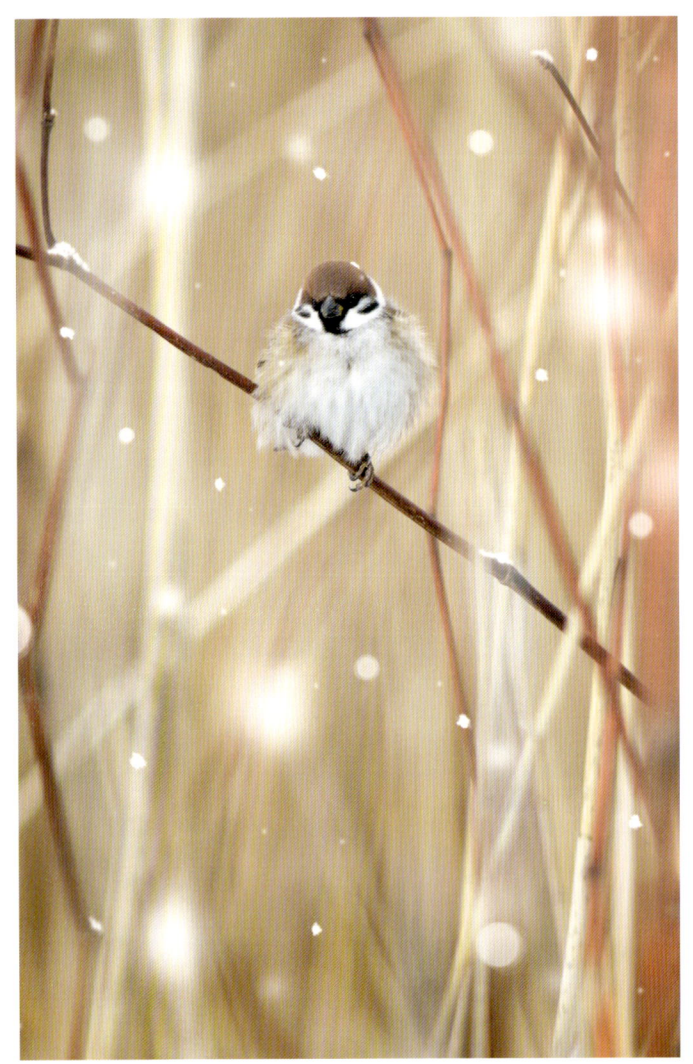

北国の冬は厳しい。

スズメたちはふわふわの羽毛で
身を守る。

モウソウ竹の枝に
とまるスズメ。

昔から「竹にスズメ」は
縁起がいいとされる。

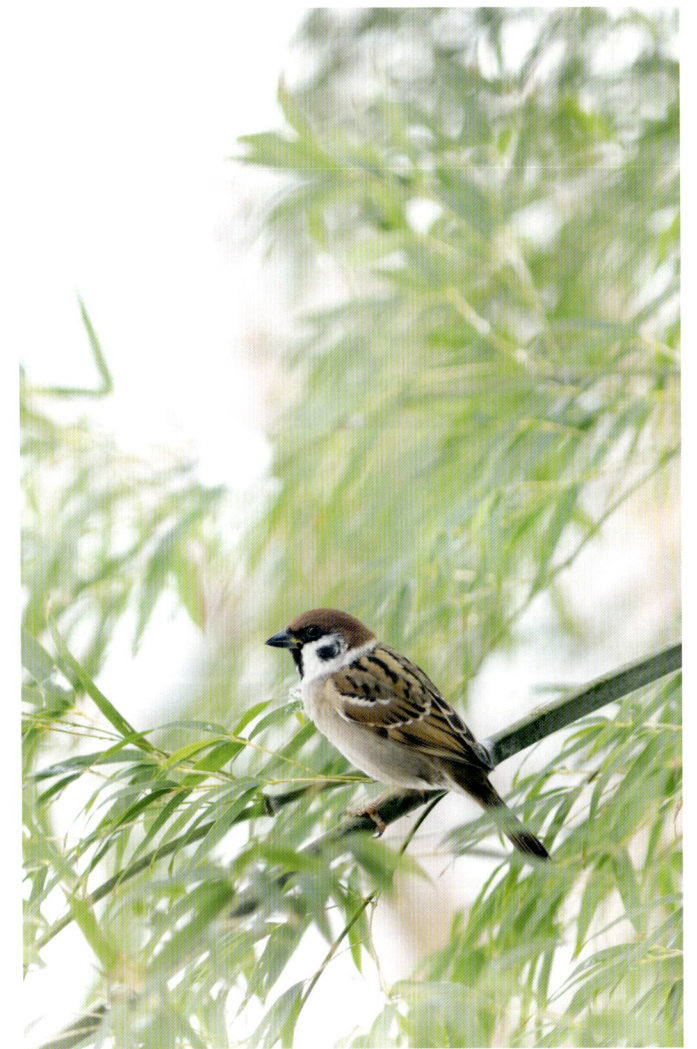

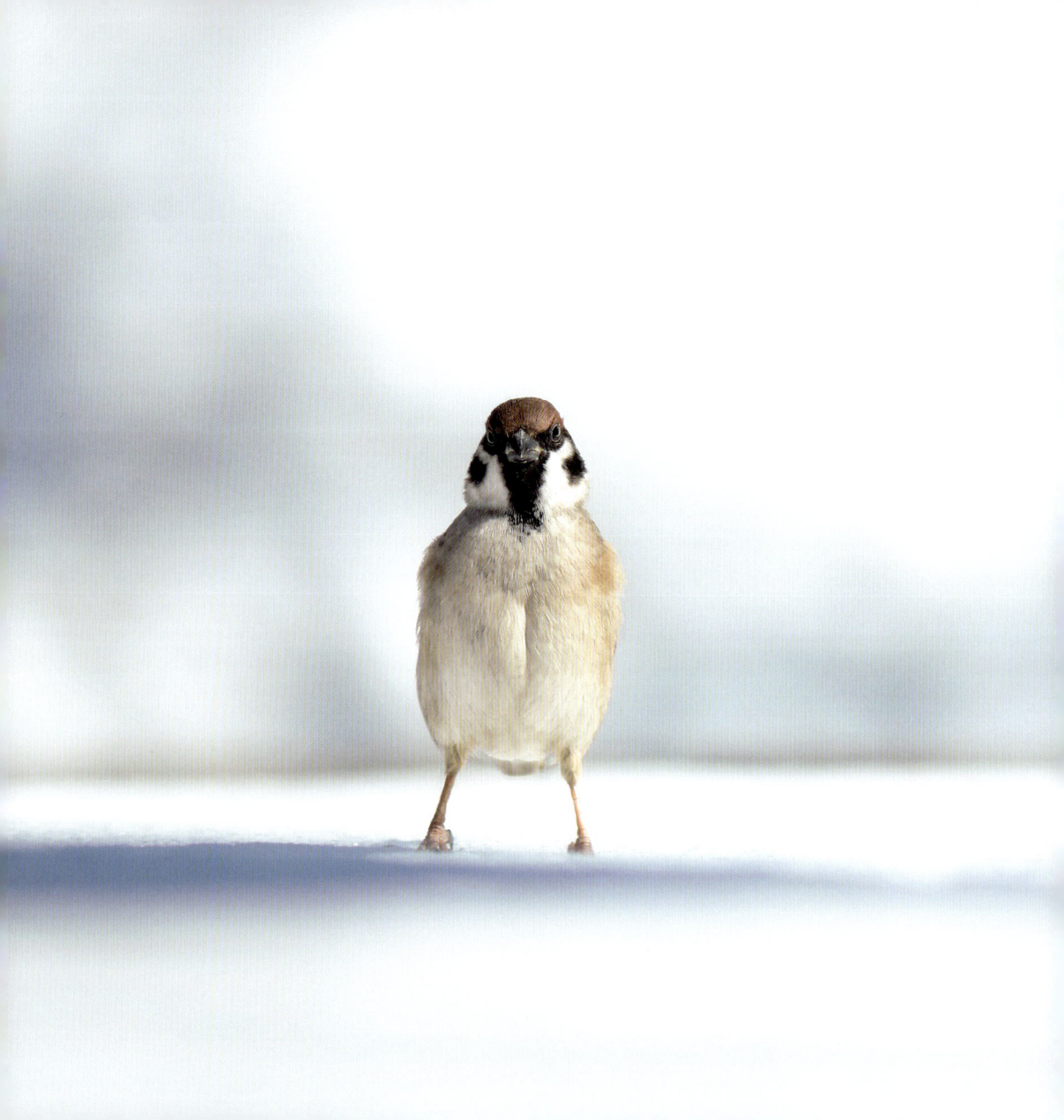

雪原にすっくと立ち、
前を見すえる一羽のスズメ。
鳥には見えず、何かおかしい。

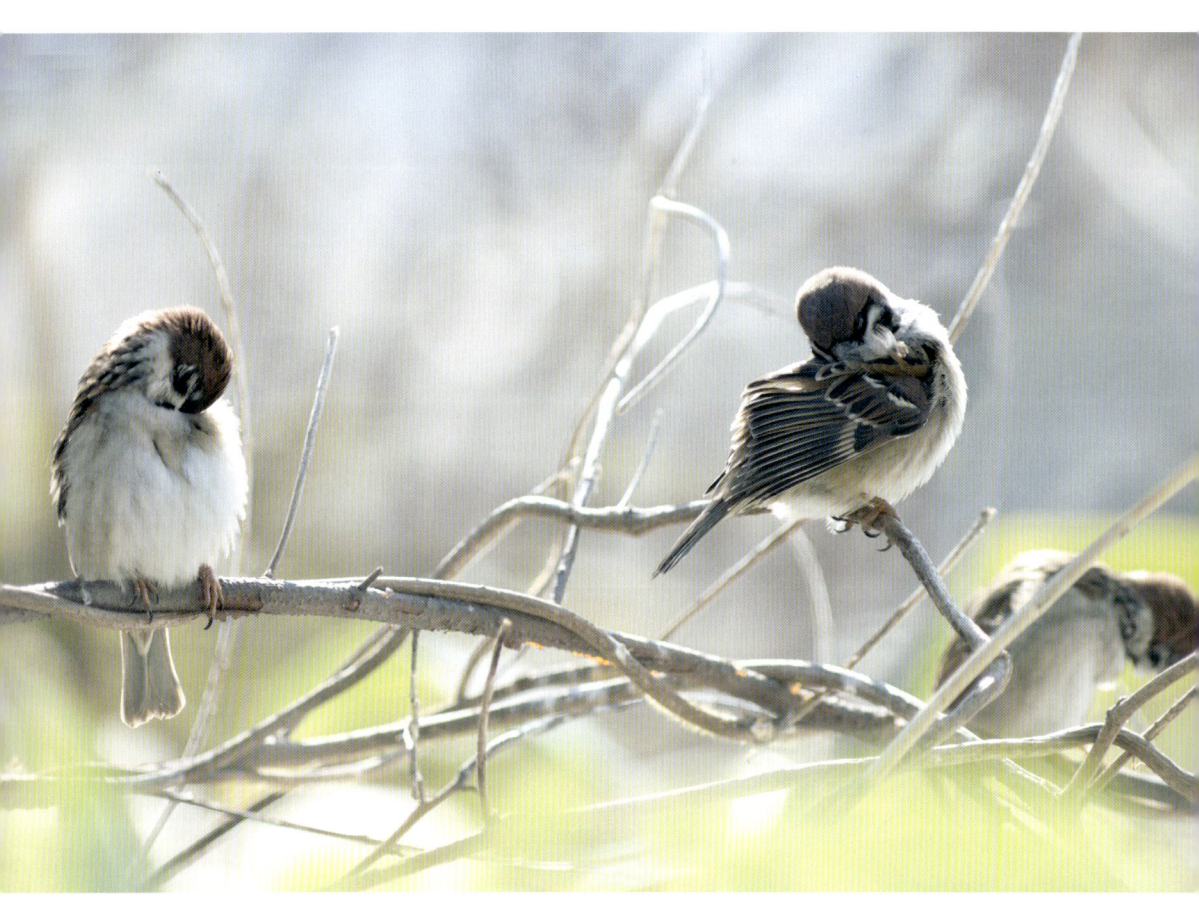

スズメたちにとって羽毛の手入れは大切だ。
休息時には欠かさない。

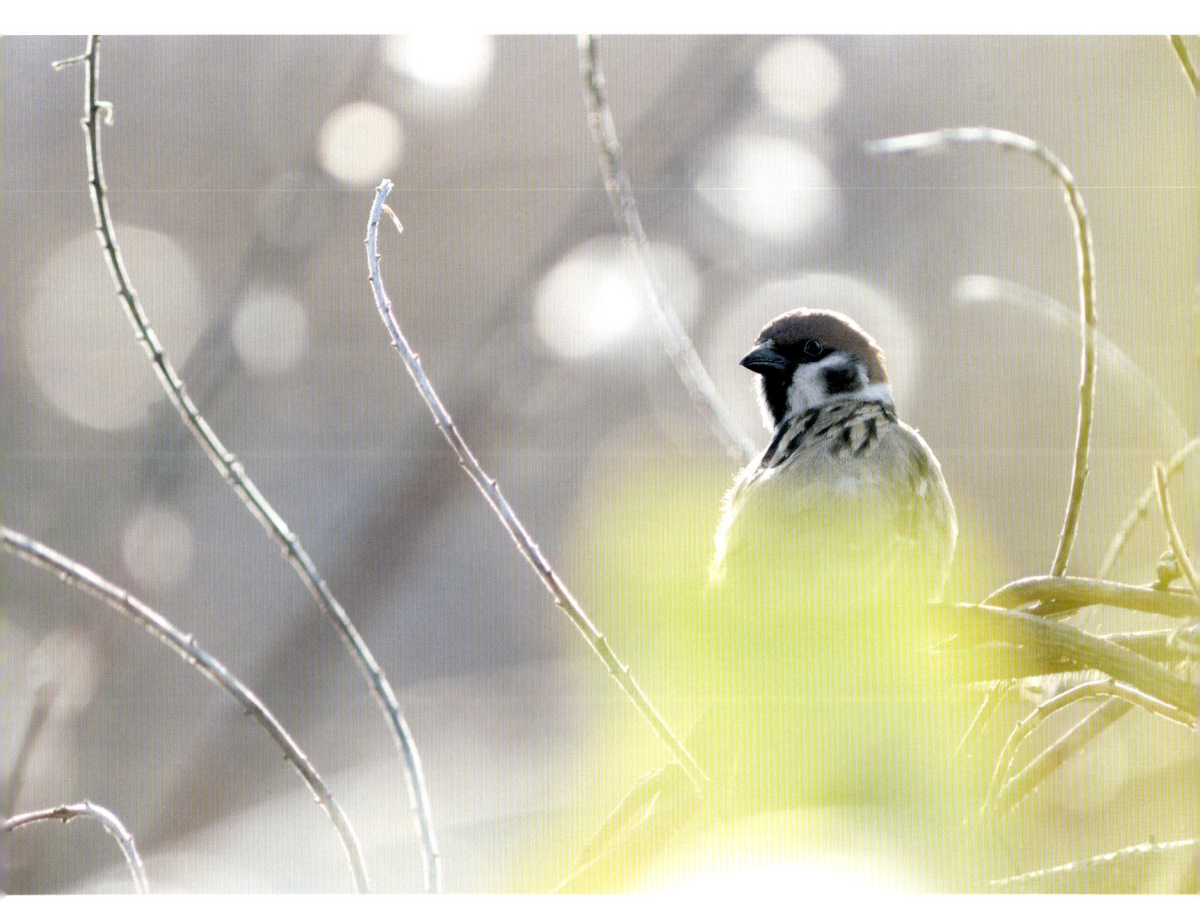

休息していても、決してあたりのへの警戒は緩めない。

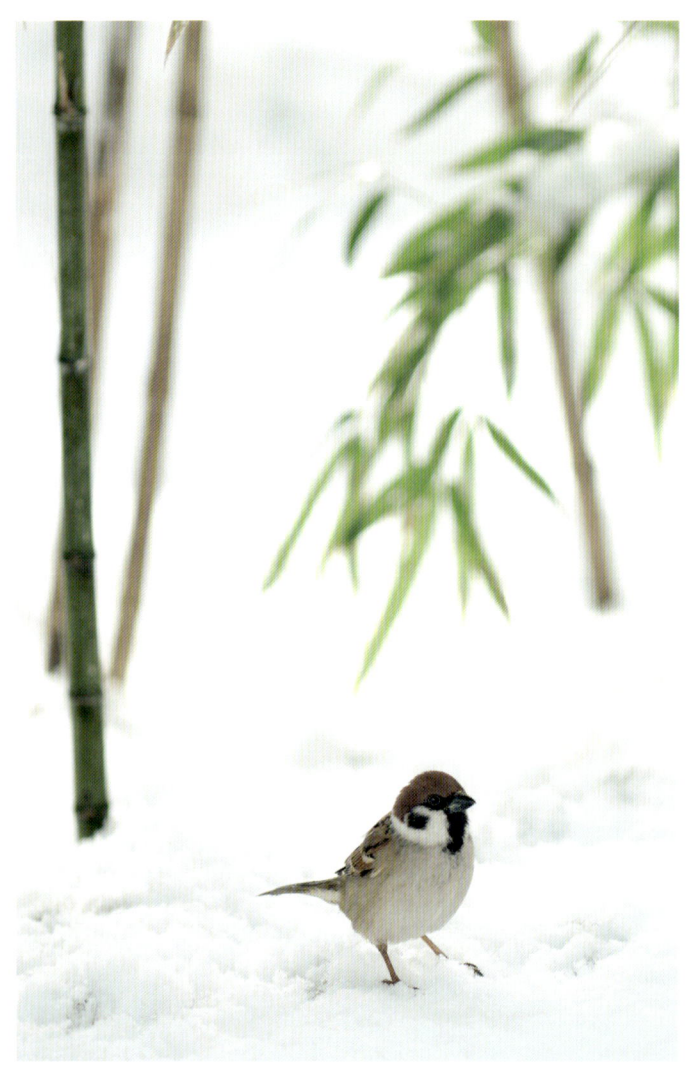

昨夜の雪が
地面を覆い隠したため、
今朝のスズメたちは
餌探しに忙しそうだった。

人の足跡が
幾つもの窪みとなっていた。
雪の窪みの中から
スズメが顔を出した。

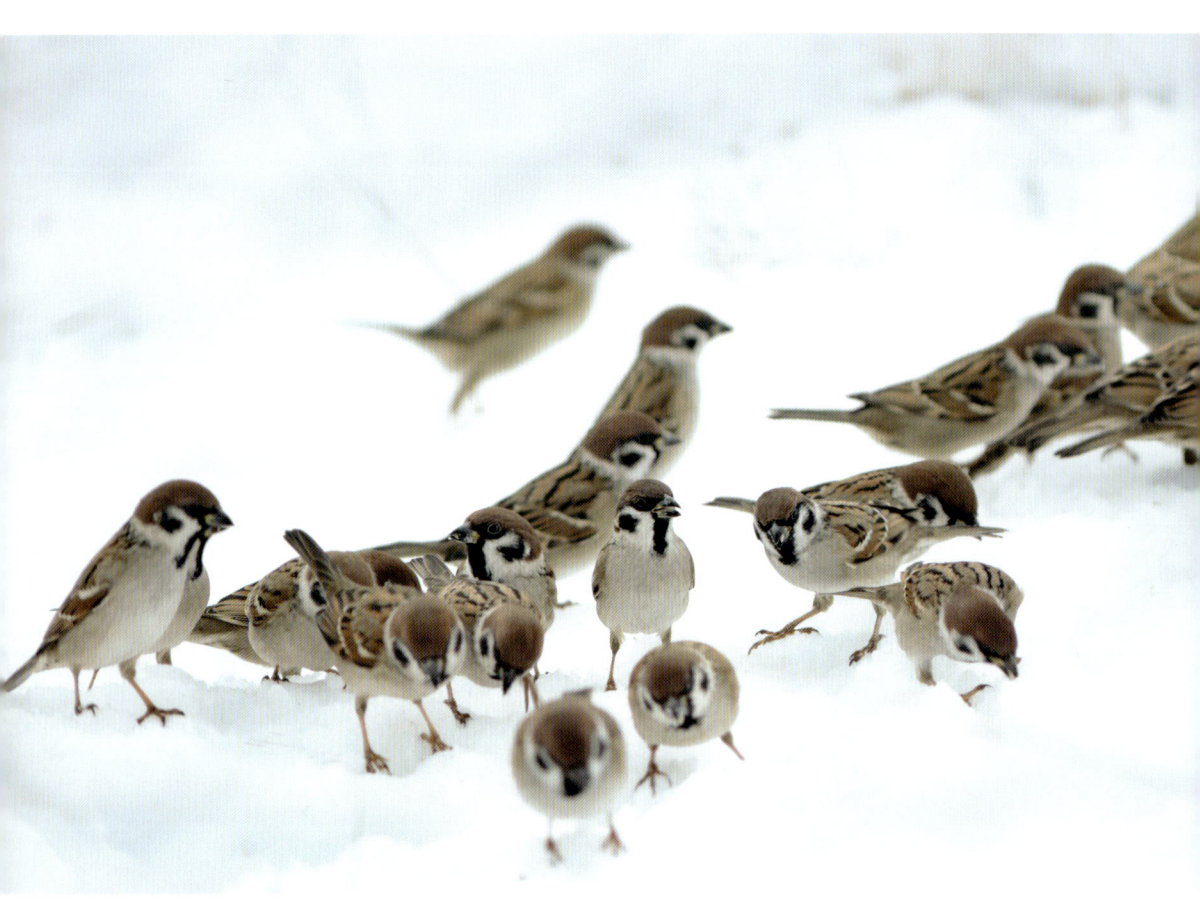

スズメの群れは雪原へと舞い降りると、いつも慌ただしく動き回って餌を探す。

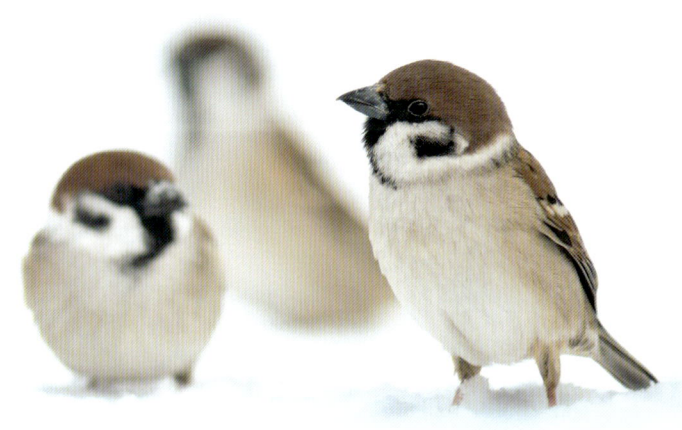

スズメを撮影していると、時々可愛い個体に出会う。
この日も雪の上にいる一際可愛い顔したスズメを見付けた。

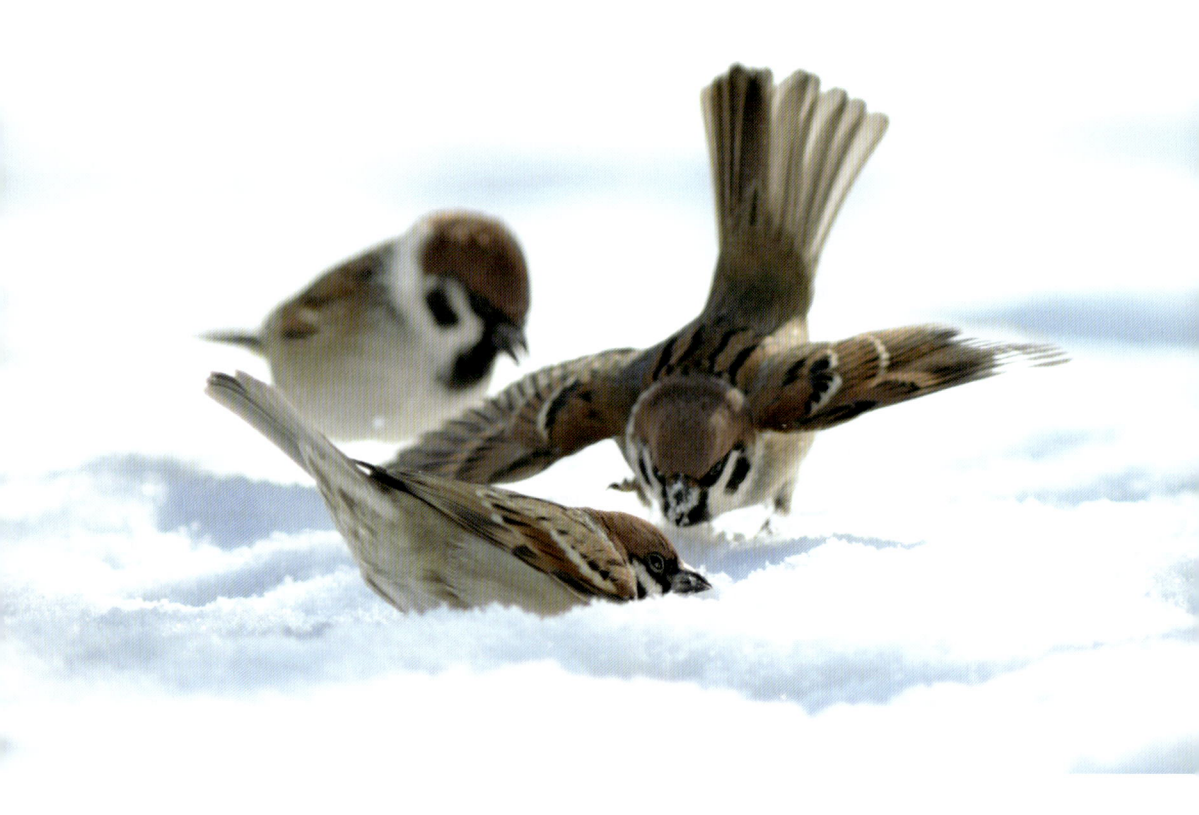

けんか相手に威圧され、「参りました」という表情のスズメ。

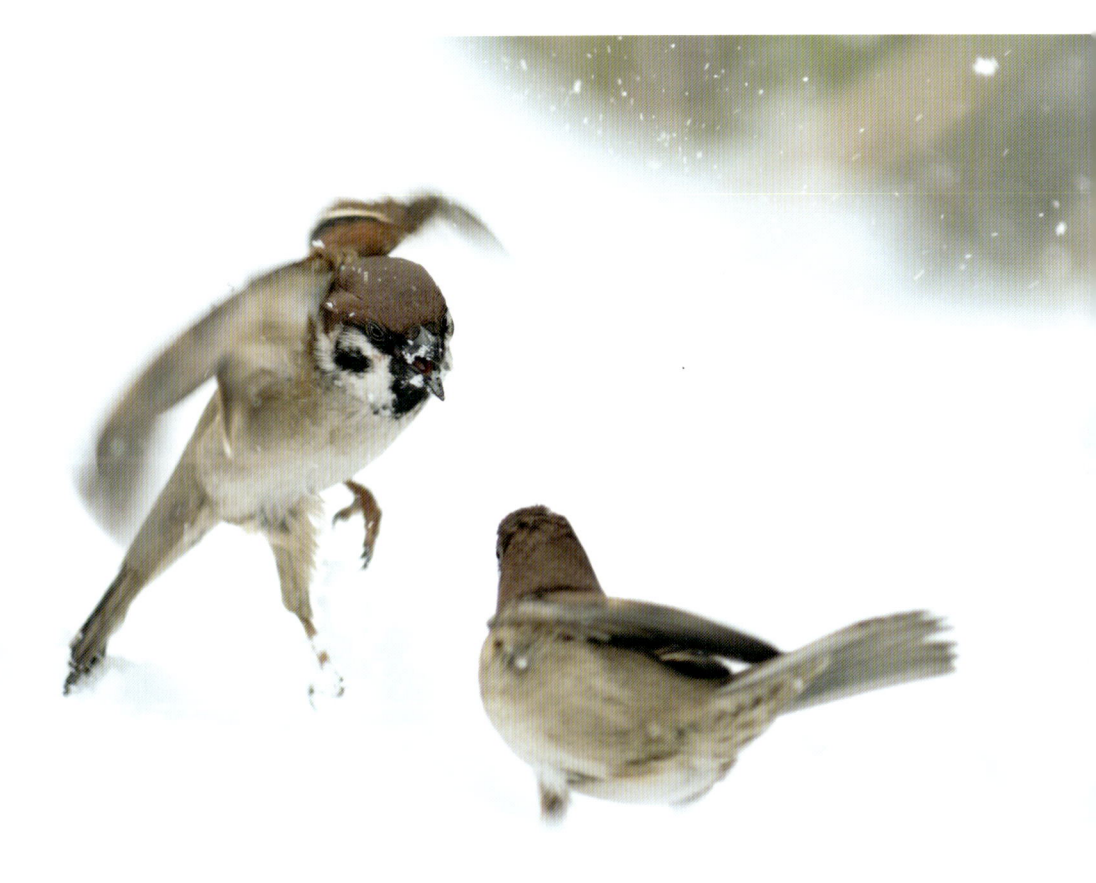

新雪を蹴散らしながら争う二羽。スズメの喧嘩はけっこう激しい。

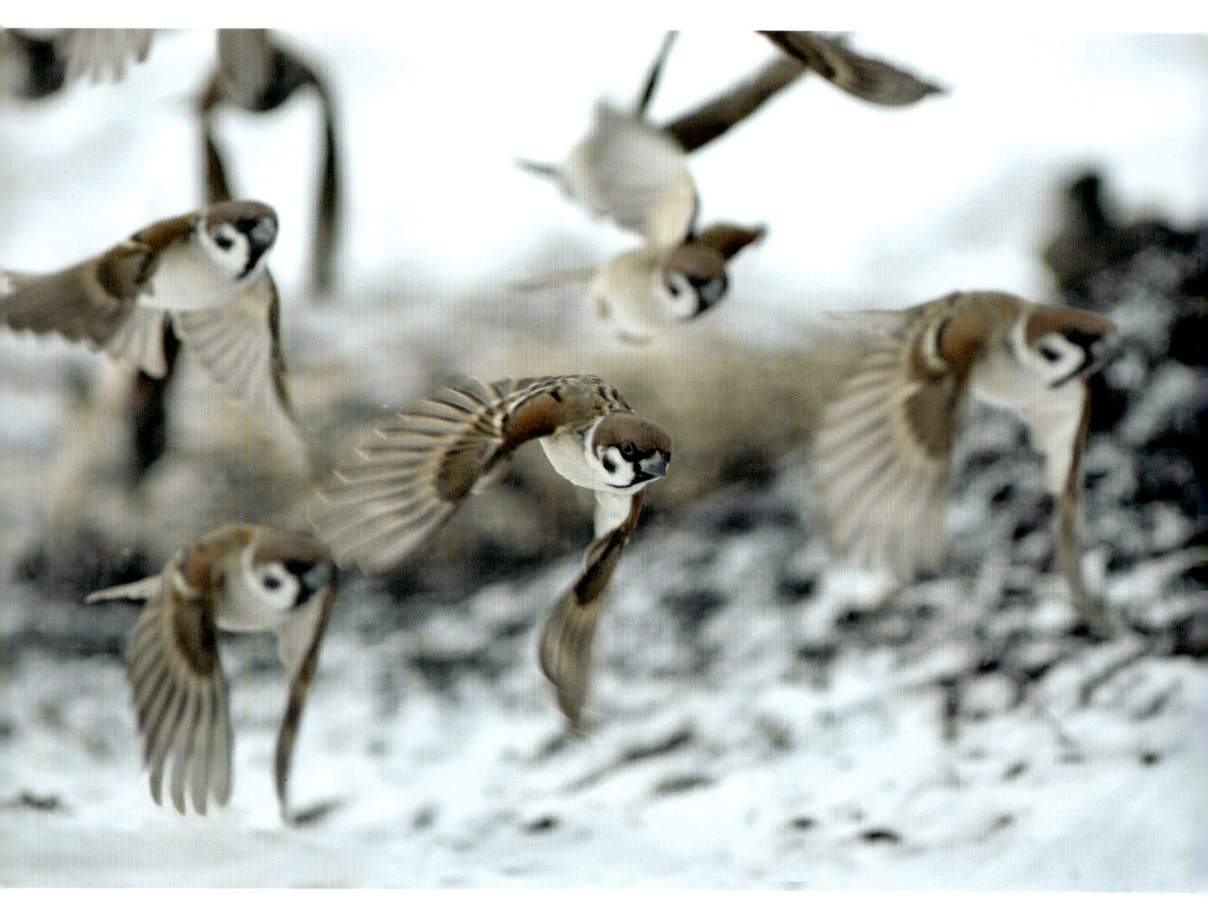

餌を求め、スズメの群れが冬の畑を飛びまわる。

畑に舞い降りたかと思ったら、
レンズを向ける私に向かって
飛んできた。

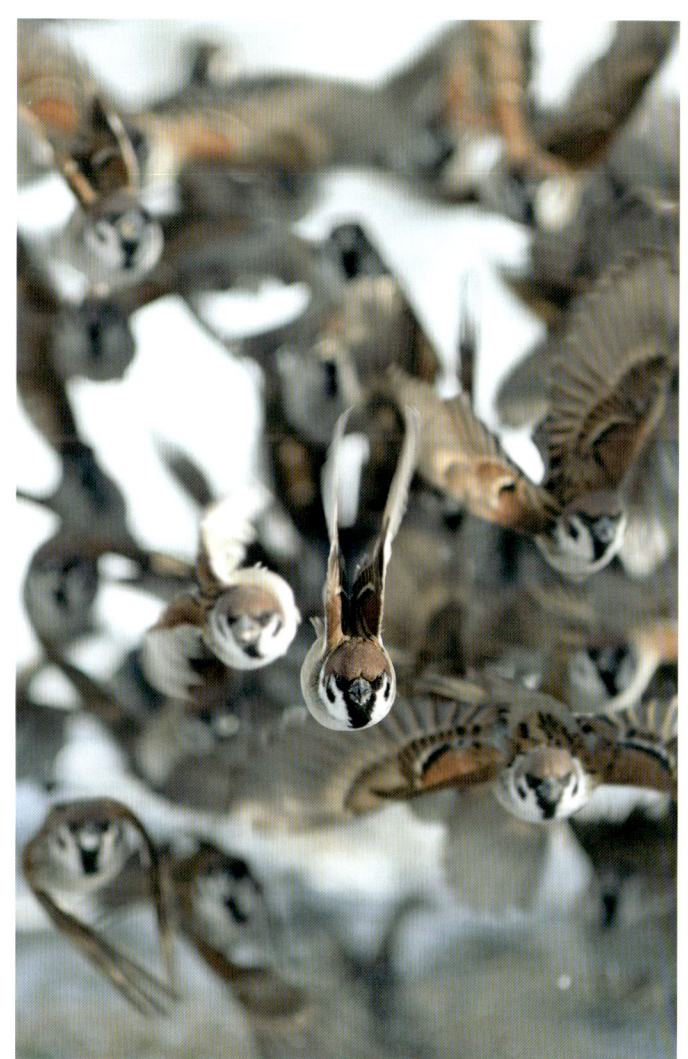

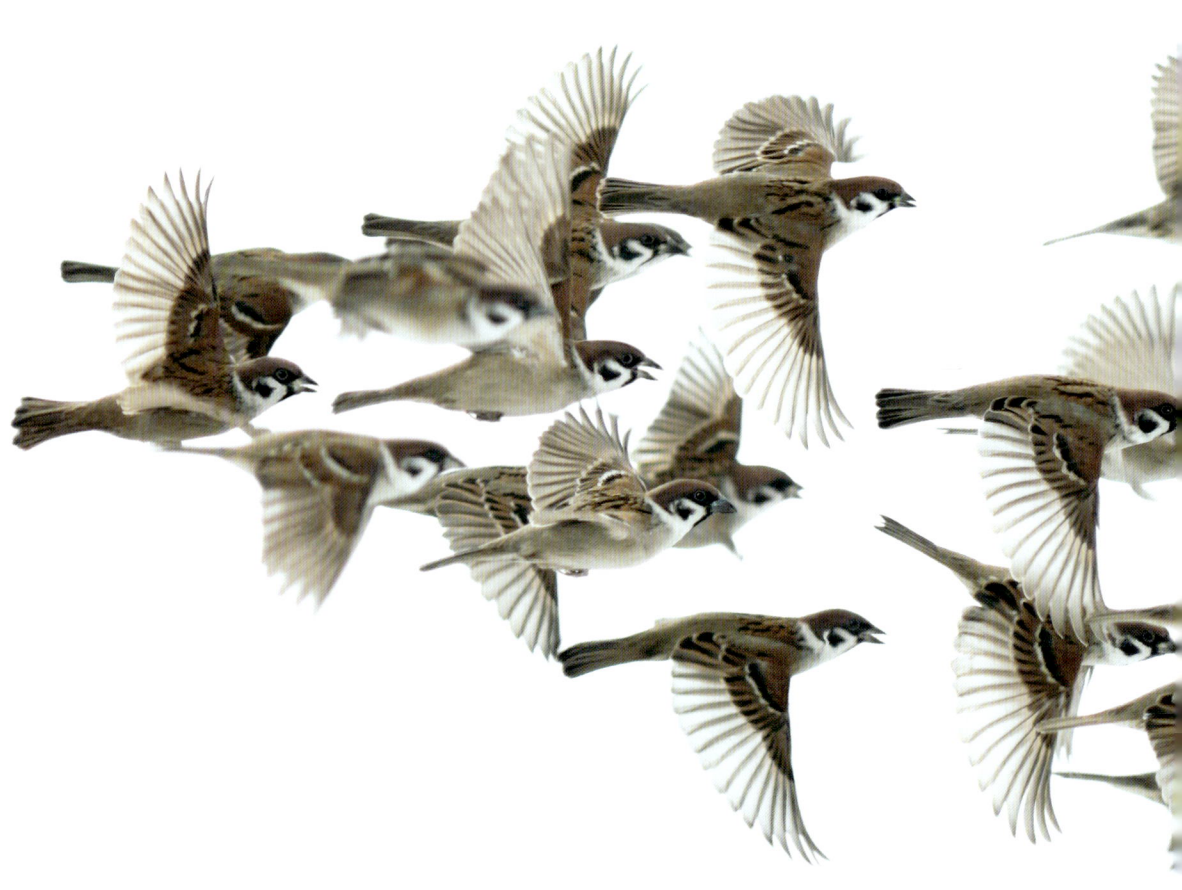

NEW PHOTOGRAPHIC SERIES

- NORTHERN LIGHTS / 谷角靖
- Dear deer / 佐藤和斗
- MADAGASCAR / 山本つねお
- 富士山 / 山下茂樹
- Dall Sheep / 上村知弘
- PENGUIN LAND / 福田幸広
- 風雅 富良野・美瑛の四季 / 高橋真澄
- 飛翔 / 松木鴻諮
- 野の鳥の四季 / 熊谷勝
- ハヤブサ / 熊谷勝
- LOVELY 愛らしい鳥たち / 熊谷勝
- BIRDCALL 光の中で / 中村利和

A5判変形 148mm×203mm / 96頁 / ソフトカバー / 各1,500円（税別）

- 沖縄・八重山諸島 / 深澤武
サイズ / 175×255mm ソフトカバー
総頁 / 96頁 定価 / 2,000円+税

- すずめ日誌 / 熊谷勝
サイズ / 168×168mm ソフトカバー
総頁 / 96頁 定価 1,600円+税

MINI BOOK SERIES

ポケット一杯のしあわせ！
いつでもどこでもいっしょだよ

- フクロウにあいたい　　横田雅裕
- モモンガにあいたい　　富士元寿彦
- クロテンのふしぎ　　　富士元寿彦
- コウテイペンギンの幸せ　内山晟
- ミーアキャットの一日　内山晟
- のんびりコアラ　　　　内山晟
- いつもみたい空　　　　高橋真澄
- はすはな　　　　　　　河原地佳子
- ゆかいなエゾリスたち　高野美代子
- キタキツネのおもいで　今泉潤
- わたしはアマガエル　　山本隆
- ラッコのきもち　　　　福田幸広
- ハッピーモンキー！　　松成由起子
- 森の人オランウータン　松成由起子
- シロクマのねがい　　　前川貴行
- 子パンダようちえん　　佐渡多真子
- キンタ・ハナ・ギンタのにゃんこ生活　佐藤誠
- 花の島の暖音　　　　　枩田美野里

120mm×120mm（手のひらサイズ）/ 39頁 / オールカラー / ハードカバー / 各780円（税別）

- 猫だって鼻提灯くらいできるもん。/ あおいとり
- 島ねこぽん / あおいとり
- 気ままに猫だもん。/ あおいとり
- 石垣島 / アサイミカ

猫だって鼻提灯…、気ままに…／各1,300円（税別）
島ねこぽん / 1,200円（税別）　石垣島 / 1,000円（税別）
148mm×140mm / 96頁 / ソフトカバー

- 美瑛 光の旅 / 中西敏貴
- 日本の城 Japanese Castle / 山下茂樹
- 写真家と行く世界の絶景 / 谷角靖

- 美瑛 光の旅 - 96頁 / ソフトカバー / 1,300円（税別）
- 日本の城 - 112頁 / ソフトカバー / 1,500円（税別）
- 写真家と行く世界の絶景 - 160頁 / ソフトカバー / 1,700円（税別）

高橋真澄四季シリーズ

A5判変形 148mm×203mm / 96頁 / ソフトカバー / 本体1,300円（税別）

株式会社 青菁社　TEL.075-634-9534　FAX.075-634-9535
詳細はホームページをご覧下さい。
http://www.seiseisha.net

2017.06

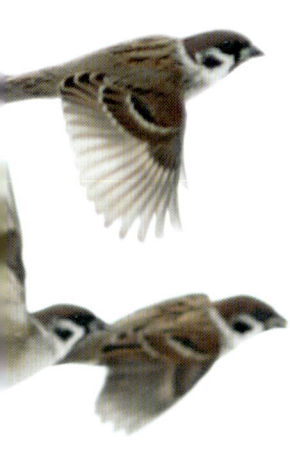
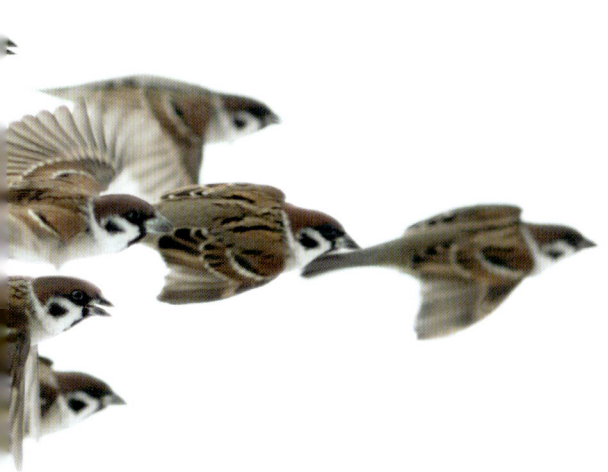

白い雪原を背景にスズメの群れが飛んだ。
翼の羽が透けてとても美しかった。

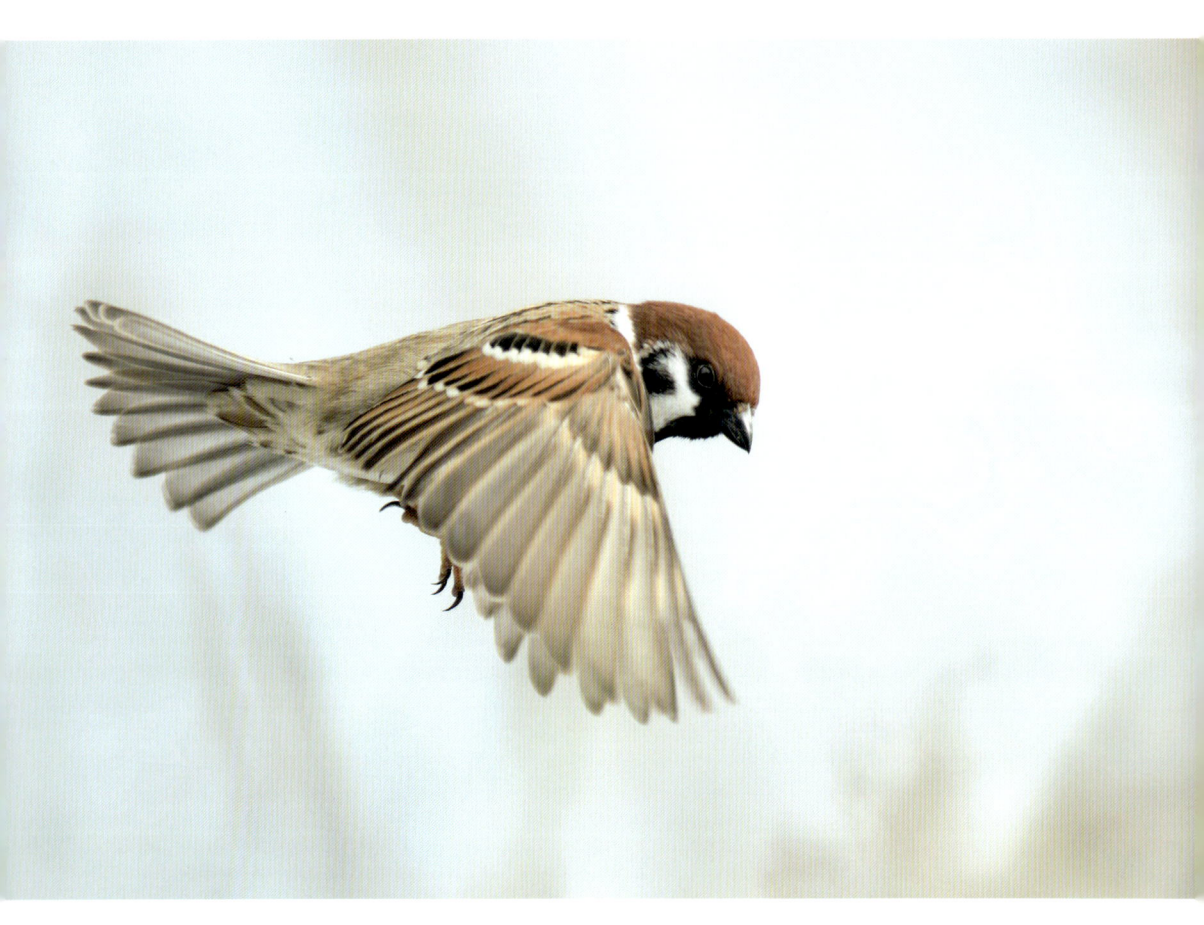

茂みから一気に羽ばたき、飛び出る。

脚を突き出し、翼を広げて舞い降りる。

ネコヤナギが大分膨らんできた。
北国のスズメたちが待ち望む春が
もうすぐだ。

春が近づくにつれ、スズメのオスたちは尾羽を上げ、
鳴きながら盛んに動き回る様になる。

オスはお気に入りのメスや恋敵のオスに出会うと、
尾羽を上げ、胸を張って自己主張する。

メスをめぐって、
時にはオス同士の
噛みつき合いになる。

三月、つがいとなった二羽が
石垣の巣の入り口で仲良く
寄り添っていた。

こちらのつがいの新居はどうやら、瓦屋根の隙間の様だ。

つぼみが膨らんできた桜の枝で、早朝、スズメの交尾が行われた。

巣作り当初は、
オスとメスが交互に
枯れ草や枯れ葉を運び入れる。

巣の完成が近づくと、
最後に鳥の羽毛を運び入れ仕上げる。

一羽のスズメがしだれ桜の枝で、しばらくピンク色の花を眺めていた。

桜の枝にとまり、
縄張りを見張るオス。

メスは卵を抱いているに違いない。
山向こうの家の屋根が、
朝の光で丸く光った。

巣ではヒナが孵ったようだ。

親鳥は春色の草むらで
ヒナたちの餌を探す。

春が訪れたとはいえ、餌となる虫たちの姿はまだ少ない。
親鳥は忙しく餌を探す。

縄張りを見張っていたオスの側に、
近くで巣作りをしていた隣のスズメが様子を見に来た。

桜の枝で羽づくろいするメスに、
邪魔ものが近づいた。

つがい相手のオスは胸を張り、
威嚇の姿勢をとる。

子育ての合間、
水浴びをするメス親。

メスは卵やヒナを温めるため、
お腹の羽毛を抜く習性がある。

こちらでは、梅の枝で隣同士のスズメがにらみ合っていた。
北海道では桜も梅も同時に花を咲かせる。

巣立したばかりの一羽のヒナが、公園の芝生の上にいた。
あどけない表情で親鳥の帰りを待っていた。

親鳥が側にやって来ると、大きな口を開け、盛んに餌を催促する。

イタドリの茎にとまり、親鳥の帰りを待つ、巣立ち間もないスズメの兄弟。

巣立ったヒナたちは「チュン、チュン」と力強い声で鳴き、親鳥に居場所を知らせる。
親鳥はその声に誘われるように、餌を咥えてヒナの元へとやって来る。

早朝、公園の木立の中に
巣立ちしたばかりの
ヒナの姿があった。

朝の光が六月の木々の
葉を鮮やかな色合いに変えた。

巣立ちしたヒナは、
数日でスズメ特有の頬と
喉の黒い模様が濃さを増す。

しかし、嘴の根元の黄色い部分は、
一年以上そのままだ。

北国の雨は冷たい。親鳥の帰りを待つ一羽のヒナが、民家の物置で雨宿りをしていた。

巣立ち間もない二羽のヒナが、新緑の葉陰で仲良く寄り添っていた。

スズメのヒナは、
巣立って一週間程で独り立ちする。

このヒナはもう独り立ちしたのであろう。
親鳥には頼らずに餌を探していた。

独り立ちした幼鳥が
雨上がりの水溜りで水浴びを始めた。
表情はやはり幼い。

一羽の幼鳥が水浴びを始めると、次々と幼鳥たちがやって来て水しぶきを上げる。

「やる気か」と、餌をめぐってにらみ合う二羽の幼鳥。

幼鳥同士とはいえ、にらみ合いの喧嘩は、しばしば激しい空中戦となる。

電線にとまる幼鳥の群れ。
幼鳥たちは独り立ちすると、幼鳥たちだけの群れを作って夏を過ごす。

親鳥たちは夏の終わりまで、二度目、三度目の子育てを行なう。

九月、もう秋の気配となった
港の埋め立て地で、
久し振りに幼鳥たちに出会った。

初秋の野原で一羽の幼鳥が、
冬羽の姿となったノビタキをめずらしそうに眺めていた。

秋の夕暮れ時、落日を惜しむかのように、幼鳥がただじっと佇んでいた。

秋の彩となったイタドリに
幼鳥がとまった。

その姿はもう
凛とした若鳥であった。

十月、室蘭地球岬の灯台付近に
スズメの群れが飛来した。

彼らは南の新天地を目指し、
海原へと飛び立って行く。

今年も晩秋の笹藪に
スズメの姿があった。
朝の光が夜露を輝かせていた。

川べりのヨシ原からスズメが飛び立つ。冷たい風が冬の到来を告げていた。

北国の田園に初雪が舞った。
スズメたちにとって試練の季節が始まる。

すべての地面を覆い隠してしまう冷たく、
重い初冬の雪は、スズメにとっては厄介者だ。

冷たい風と雪が容赦なく、
襲いかかる。

二羽のスズメは
ただじっと耐えていた。

スズメたちは生きるため、雪の上に残されたわずかな草の種を探し、必死についばむ。

冬の午後、逆光線が寒さから身を守る羽毛を光らせる。

とめどなく降り続く綿雪が、
スズメの冠となった。

草丈が高いヨモギの種は、
スズメたちにとって冬の貴重な餌である。

雪が小降りになると、
笹藪の中に潜んでいたスズメが、
やっと姿を現した。

冬の夕暮れは早い。

スズメがねぐらの笹藪へと
帰ってきた。

奥に止めてあった車の窓が、
まるで月のように光り輝いた。

冬の朝、木立の背後から朝日が顔を出した。
北のスズメたちの一日が始まる。

『人と共に生きる鳥』

　スズメは小笠原諸島を除く、日本全国で見られる最も身近な野鳥です。スズメたちは晴れた朝早く、民家の屋根や電線にとまり、「チュン、チュン」という耳触りのいい声で鳴き、人々の目ざめを誘ってくれる愛らしい存在です。

　スズメはどこにでもいる鳥という印象がありますが、実はそうではなく、その場所に人の暮らしがなければ、生息していません。逆に人の暮らしがあれば、必ずそこにスズメの姿があるのです。そのため、山間部の集落で過疎化が進み、人が住まなくなってしまうと、すぐにスズメたちも姿を消してしまいます。スズメは人間の生活環境と深い関わりを持つ鳥なのです。

　スズメが人と深く関わる事には理由があります。それはスズメの巣作りする場所が、民家の壁や屋根の隙間などを好んで利用するためと、人間のすぐ側で子育てすることによって、彼らの天敵となる猛禽類やヘビなどに襲われる心配がないからです。それに、人が暮らす近くには餌場となる畑や田んぼがあり、住宅地の中には小鳥たちのために餌台を設置する愛鳥家の方も多くいます。また、冬場には公園や街路樹などの茂みが安全なねぐらとなるのです。スズメたちにとって人が住む環境は、食と住と安全が備わっている最も暮らしやすい場所なのです。

　ところでスズメは渡りをしない鳥というイメージがありますが、北海道内に生息するものの一部は、秋に本州方面へと移動します。毎年十月中旬頃になると、室蘭地球岬の周辺では普段見ることがないスズメたちの群れが現われます。スズメたちは早朝より、三々五々岬に集まり、数十羽から数百羽の群れになると、ハヤブサの襲来を避けながら対岸の駒ケ岳方面を目指し、一斉に海上へと飛び立って行きます。南下するスズメたちのほとんどは、嘴の付け根がまだ黄色い今年生まれの若鳥たちです。やはり、若鳥たちにとって北国で冬を越すことは容易なことではないのでしょう。しかし、北の地に残るものと、南へと旅立つものの区別はいったいどうやって決まるのでしょうか、不思議です。今朝、あなたが目にしたスズメは、ひょっとして北海道生まれかもしれません。

あとがき

　私がスズメを撮影対象として初めて意識したのは、今から三十年程前、江戸時代中期の画家長沢芦雪（ろせつ）が描いた「竹雀図」を画集で見たのがきっかけでした。この絵は縦長の構図で描かれた水墨画で、細い竹の根元に三羽のスズメが何とも可愛げな姿で描かれたものでした。いつも見馴れたはずのスズメがとても魅力的に描かれており、この時、私もこんなスズメたちの姿を撮影したいと心から思ったのです。しかし、当時は北海道へ移住した当初から取り組んできたハヤブサの撮影に集中していたため、スズメを撮影する余裕はありませんでした。あれから歳月が過ぎ、昨年やっとハヤブサの撮影が一段落したことで、スズメの撮影を開始したのです。

　スズメを撮影する上で私には大きな課題がありました。それは「竹（笹）とスズメ」です。昔から「竹にスズメ」という言葉がある様に、竹とスズメは付きものです。そのため、私は何としても日本のスズメらしい「竹にスズメ」の写真を撮影したかったのです。スズメをまとめる上でこの写真がなければ、スズメの写真集とは言えない気がしました。「竹にスズメ」はこれまで水墨画や日本画などのテーマとして数多く描かれてきましたが、実際に写真撮影されたものを私は今まで見た事がありませんし、私自身もこれまで一度も竹や笹にとまるスズメの姿を見た事がありませんでした。そこで一ヶ月ほど室蘭近郊で撮影できそうな場所を調べてみました。その結果、隣町に道内ではめずらしいモウソウ竹と細い竹の小さな竹藪がある事に気付きました。ここにはスズメが多く生息しているため、竹とスズメを写し込むことができるのでは考え、冬の間しばらく通い続けることにしました。そして、二月の寒い朝、私が長年イメージしていた「竹にスズメ」の光景を撮影することができたのです。

　近代日本画の巨匠竹内栖鳳は身近な生き物を多く描きました。特にスズメ好きで知られ、晩年自身の画業を「スズメで始まり、スズメで終わる」と語ったといいます。それほどスズメは魅力が尽きない鳥なのです。私も新たな表現を目指し、今後もスズメたちの撮影を続けたいと思います。

すずめ日誌

発行日	2016年11月7日 第1刷
	2017年1月27日 第2刷
著者	熊谷 勝
企画・編集	KENZAN
印刷	サンエムカラー
製本	新日本製本
発行者	日下部忠男
発行所	青菁社

〒601-8453 京都市南区唐橋羅城門町40番地3
TEL.075-634-9534　FAX.075-634-9535
http://www.seiseisha.net

ISBN978-4-88350-313-1
無断転載を禁ずる